I AM MARU
まるです。
mugumogu 写真と文

WILLIAM MORROW
An Imprint of HarperCollins Publishers

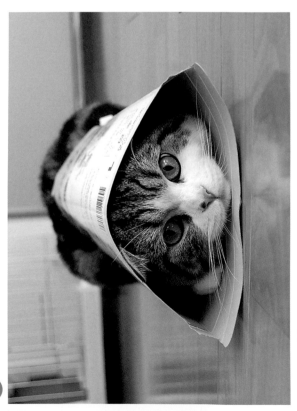

Hello, this is Maru. 自己紹介します。

Hi! I'm Maru.

Born on May 24, 2007, Maru is a male brown tabby Scottish Fold, who looks like he is wearing a pair of charming white gloves and socks. You would expect to see folding ears on a Scottish Fold, but Maru is prick-eared. You will find out more about Maru later, but here he comes for self-introduction.

はじめまして、まるです。

まるは2007年5月24日生まれの、スコティッシュフォールドの男の子。スコティッシュフォールドといえば折れた耳を想像する人もいるかもしれませんが、まるは立ち耳です。毛色はブラウンタビーで、真っ白な手袋とソックスが自慢です。

まるはこの自慢の手袋で、たくさんのやんちゃをしてくれます。これからまるについて、いろいろと紹介していきますね。

まずは軽く、まるさんに挨拶してもらいましょう。

Hi, I'm Maru. Reputedly I'm a very good boy, but I can be naughty sometimes.
どうも、まるです。時々やんちゃもしますが、普段はとってもいい子だと評判ですよ。

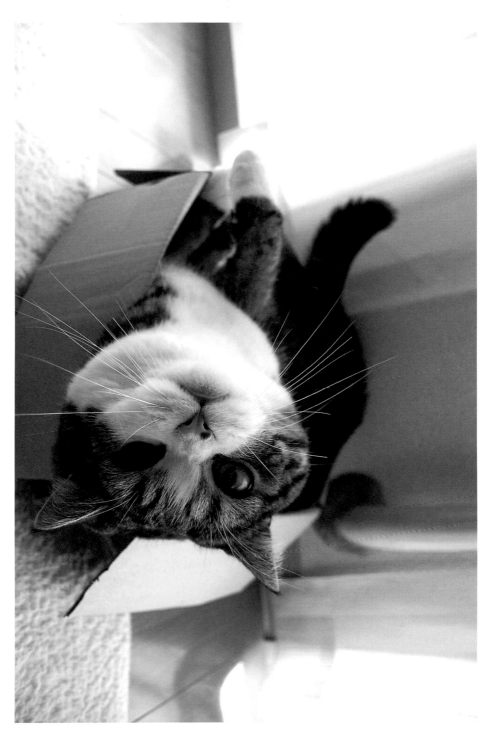

And I'm round in shape just like my name means in Japanese. . . . Hey, who said that?!
名前の通り丸い奴だと言うのは。誰ですか?

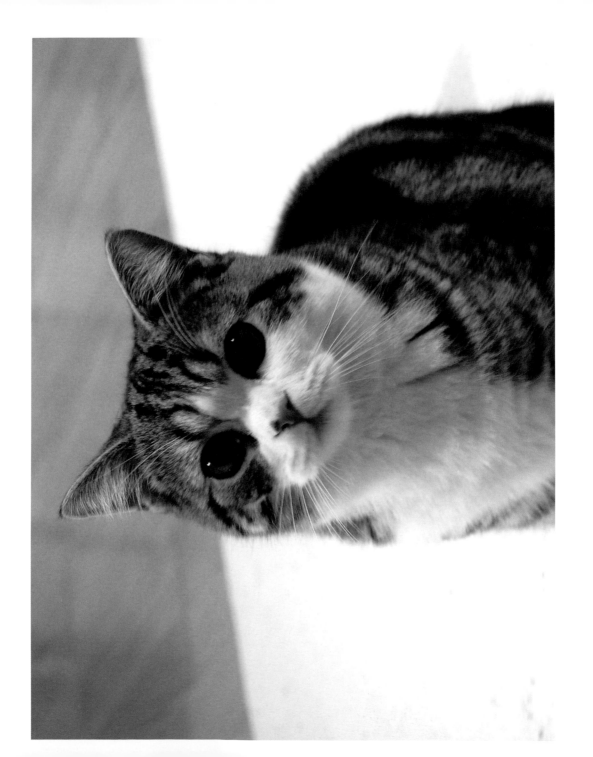

About his name, "Maru":

"Rounded shape (Marui)" was my first impression of him. Round eyes, face . . . everything! Actually it wasn't the reason I came up with the name, though. I've always wanted to name my cat "Maru" because it's easy to call. Soon Maru learned his name coupled with the time of meals. When he hears his name, he comes rushing over to me with great anticipation. Well, sometimes I just call him for no reason. Sorry, Maru!

"まる" という名前について。

まるを初めて見た時の印象は、とにかくまるい 目も顔もまんまる。でもそれが "まる" という名前の由来になったわけではなく、実はまると出会う前から決めていました。色々と考えたのですが、最終的には呼びやすさを第一に決めました。簡単だから、まるもすぐに自分の名前を覚えてくれました。だけど今はやみに名前を呼びません。なぜかというと、名前を教えるにあたって、ご飯の前に必ず「まる」と呼ぶようにしていたのですが、そのおかげで、今では名前を呼ぶと、ものすごく期待に満ちた目ですっ飛んで来てしまいます。ごめん、別に大した用じゃ――ということもしばしば。

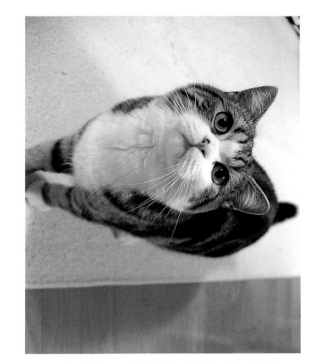

Oh, time for snack?
おやつですか?

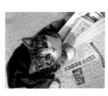

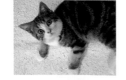

About "Chibi-Maru"
(Chibi means "little")

When Maru first came to our house, he was about four months old and weighed five pound six ounces. The image of him was more like "a little cat" than a "kitten" then. On the first day, I thought he would be scared and hide himself in the corner, but, in fact, he was totally fine. As soon as I took him out of the carrying case, he started sniffing around the room, food plate, scratcher, etc. He also quickly learned about the sand tray. First I showed him how to dig the sand with his paws. After a couple of times, he did his first poop all right.

チビまるについて。

まるは生後4ヵ月ほどで家にやってきたのですが、その時すでに体重が2.4キロあり、仔猫というより幼猫といった感じでした。初めての家。最初は怖がって隅の方に隠れてしまうかなと思っていたのですが、キャリーケースから出したとたん、まんまるな目と顔で探検を始めました。まるのために用意した爪とぎや食器などを、鼻をずんずん言わせながらひとつひとつチェックしていきます。トイレもすぐに覚えてくれました。「ここがトイレだよ」と、まるの手を持って、3回砂を掻いてあげます。するとひと通り探検したあと、ちゃんと自分でトイレのある場所まで行き、立派なうんOをしO立派なうんOをしました。

6

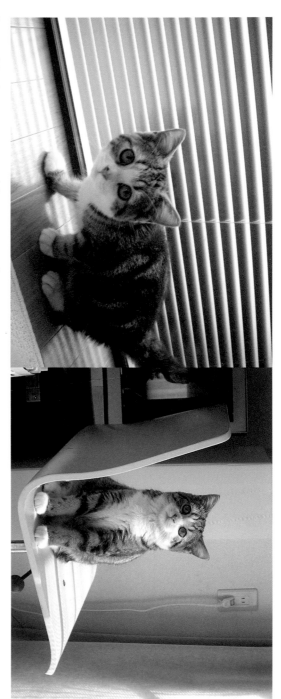

I used to be compared to an angel.
チビの頃は天使のようだったと言われます。

Well, then, what will it be now?
じゃあ今は何だっていうんでしょうね。

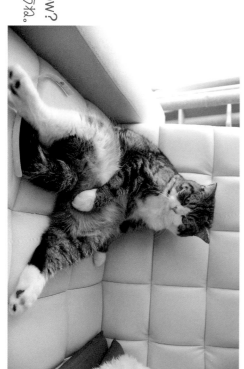

A little monster!!

Baby Maru was very mischievous and curious about everything. Anything that moved became Maru's toy. He would jump from the shadows if I started to wipe the floor, boldly leaping against the vacuum cleaner. By all possible means he did exactly what I told him not to. For example, when I spotted him trying to jump in the trash box and I called out "No," he got more excited and motivated. Today he puts his head into the trash box when he wants my attention, as if he's provoking me. I say "No!" and he runs away. That's how our chasing starts. He knows the meaning of "No." I might as well accept his invitation and start to play with him.

とにかくやんちゃでした。

チビの頃のまるは、とにかく好奇心が旺盛で、やんちゃでした。動くものはなんでもまるのおもちゃ。床のぞうきんがけをすれば物陰から狙って飛びかかってくるし、掃除機にも果敢に挑んできます。そして「ダメ」と言われたことは、なんとしてでもやり遂げる。ゴミ箱に入ろうとするのに「ダメだよ」と言うと、興奮してますますやる気を出し、出されてはまり、出されてはまり。それを繰り返すうち、どうやらまるはゴミ箱に入れば人が動くし と学習したようで、構ってほしい時にわざとゴミ箱に頭を突っ込んで挑発してくるようになりました。私が「こらっ」と言って立ち上がると、ダーッと逃げて行き、追いかけっこの始まりです。「ダメ」という言葉を理解したうえでわざとやられては、もう遊びに付き合うしかありません。どうやらまるの方が一枚上手だったようです。

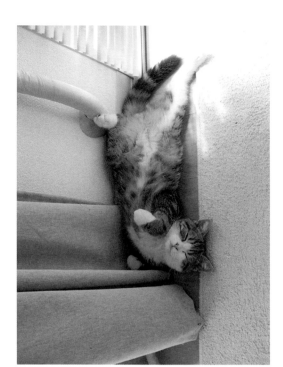

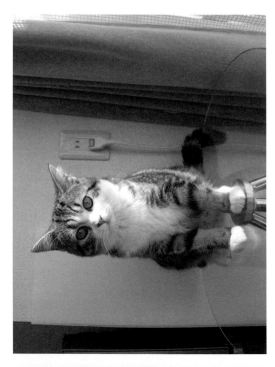

8

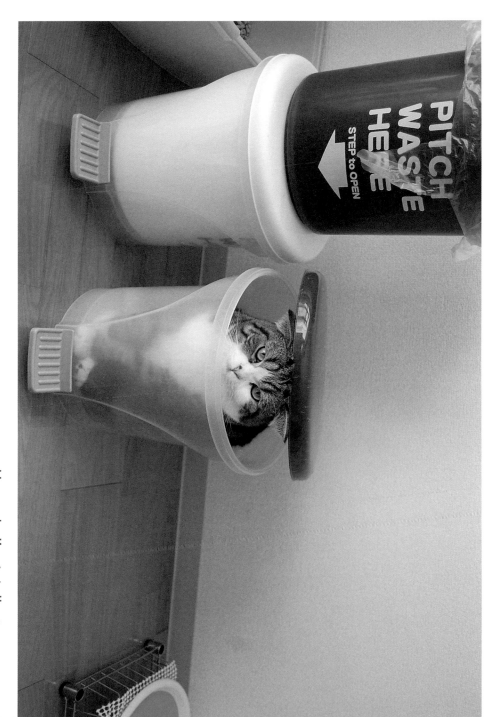

Hmmph, I'm totally grown up now!

今では立派な大人になりましたよ。

Résumé

- **Name:** Maru
- **Date of birth:** May 24, 2007
- **Breed:** Scottish Fold
- **Sex:** Male
- **Color:** Brown tabby
- **Height:** 2 feet 6 inches (including tail)
- **Weight:** 12 pounds

- **Charming features:** Round face and white socks
- **Personality:** Cool and going his own way; good-natured but takes correction poorly
- **Hobby:** Troublemaking
- **Special skill:** Sliding into any open box
- **Language skill:**
 - "Maru"—acknowledges with single mew
 - "Meal time"—rushes right over
 - "No!" and "Wait!"—often ignores even though he knows the meaning

You say I'm such a naughty boy?
I don't know what you're talking about.

趣味が悪事全般? 悪いことなんてしてませんよ。

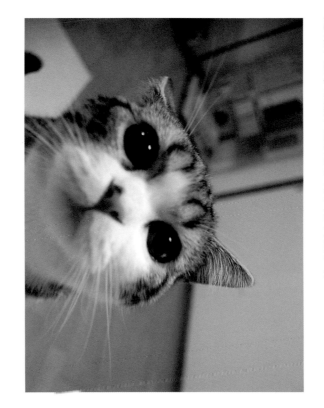

Not really . . .

本当ですよ。

November 23, 2007

I'm quite hunched over and can't sit up straight.
I'm good at yoga, though.

I heard my housemate started a blog.
She asked me how long I think it would last,
so I just looked away. . . .
Last time she kept her blog for over one year,
but one day she erased the whole thing.

So maybe that will happen again.
I heard humans can't change overnight.

どうしてもまっすぐに座ることができません。
体が歪んでいるのでしょうか。
ヨガなら、得意なんですけどね。

同居人がブログを始めたようです。
いつまで続くと思う？ と訊かれたので、目を逸らしました。
前にやっていたブログは、1年以上続けたにもかかわらず、
ある日突然、全て消去したそうです。
だからたぶん、今回もそうなるでしょう。

人はそう簡単には変われない。そう聞きますから。

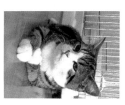

I had a hard time on last Sunday. I pooped twice. Every time I did, my housemates (male and female) screamed and took me to the bathroom. The second time was worse.

What was that all about? These people trying to shove me out to each other, saying "Yikes!" Come on! Aren't they neat freaks?

Yeah, I did step on my poop, but if I keep walking around, it will eventually get cleaned off, right? I will also lick my paws to make sure, of course. I wanna tell them that I'm neater than they are! Seriously!

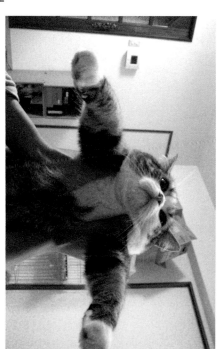

この間の日曜はさんざんでしたよ。
2回うんちしたんですけど。

そのたび同居人（オス＆メス）がぎゃーぎゃー騒いで、
風呂場に連れて行かれるんです。
2回目の時なんて、ひどいもんですよ。

なんですか、これは。

こんな状態のまま同居人たちは、
「やだやだ」

なんて言いますが、ぼくのおケツにつけ合いですよ。
まったくもう。

同居人はどうも、少し神経質でいけません。

うんち踏んづけたってね、
歩いていればそのうちキレイに去るんです。
仕上げに舐めれば、もうピッカピカ。

お前らよりよっぽどぼくはキレイ好きだと、言ってやりたいですよ、
ほんと。

November 27, 2007

This is my favorite spot.

ここがお気に入りです。

I'm not afraid of water.

水なんてへっちゃらですよ。

Fresh water is the best.
I choke sometimes, though.

新鮮なお水は、やっぱ最高ですね。
毎回むせるのが、たまにきますずですけど。

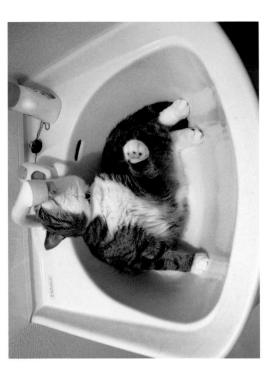

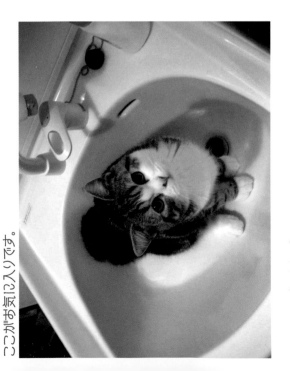

But my housemate treats me like a nuisance.
This is totally annoying.
I was here first.
Wait for your turn, please.

それなのに同居人ときたら、
ぼくを邪魔者あつかいするんです。
心外ですね、まったく。
ぼくが先に使ってるんです。
順番は守ってくださいよ。

I'm going to take a nap.
Please come back in two hours.

ちょっと寝るんで、
2時間後にまた来てください。

14

I can't believe my housemate!

まったくもう、同居人には参りました。

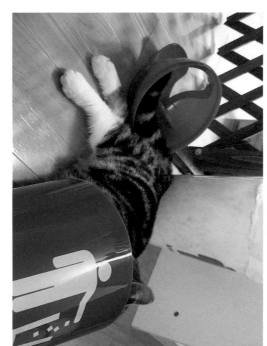

I enjoy getting in the trash box.
It's my hobby.
How many times do I have to tell her?

ゴミ箱に入るのは、
ぼくの趣味ですよ。
なんど言えばわかるんですか。

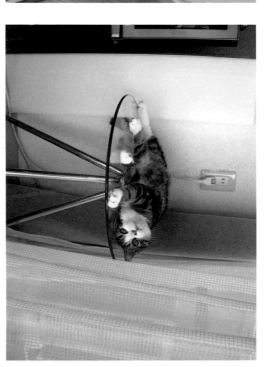

But she yells at me every time.
She is such a slow learner. . . .

それなのに同居人ときたら毎回、
「コラ」
なんて大声を出すんです。
物覚えが悪くて困ります。

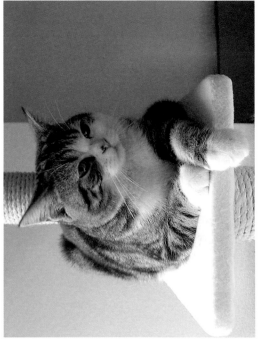

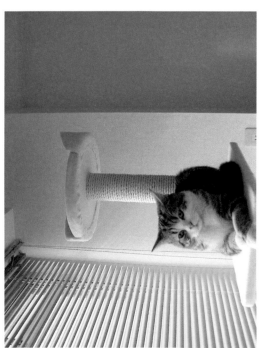

October 10, 2007

Hey, who said I'm fat?

誰ですか、デブなんて言ったのは。

Yes, I'm six months old and weigh nine pounds.
But I'm not fat, and I got an endorsement from the doctor, even though my housemate was always asking him,
"Is he fat?"

That's rude, don't you think?

失礼ですよ、まったく。

6カ月で4キロあったってね。

デブじゃないんですよ。

体が大きいだけなんです。

獣医さんのお墨付きも、もらってますよ。

同居人がしつこいくらい、確認してましたけね。

「これはデブですか」

って。

16

December 10, 2007

I got chewed out.

叱られました。

My housemate bought me some cat grass in a pot.

猫草を買ってもらったんですけどね、

I was too excited and next thing I knew . . . it turned out like this.

つい、つい調子に乗りすぎまして、気がついたらこんなことになっていたわけで。

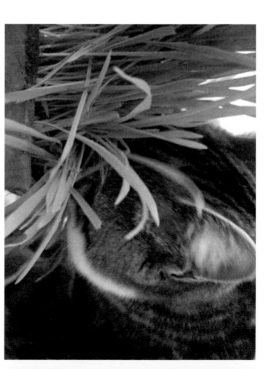

She's not going to buy me any more.

もう買ってもらえなさそうです。

Encounter

Maru came to our house on September 21, 2007. That was the day after I moved in to an apartment where pets were allowed. He must've been excited. He was running around the room for a long time. Finally he lay down on the cold wooden floor. I was worried that his belly was chilly, but as soon as I moved him onto the squashy bed, he jumped out. Maybe he didn't like the textures. I wrapped him in a bath towel instead, but he escaped from me again. I soon learned that he doesn't like anything warm.

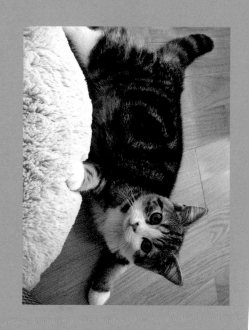

M. Because there is a box. そこに箱があるから。

A video made Maru famous.

He loves chasing the most. One day he happened to slide in the cardboard box while chasing. It's really slippery on the wooden floors. After many trials, he learned the tricks and developed his sliding skills to go faster and farther, like a rocket. Now he enjoys the sliding bit itself! This is how the video that made Maru famous came about.

まるを有名にした1本の動画。

まるの一番好きな遊びは、追いかけっこです。たくさんの人に知ってもらうだくさんのきっかけになったあのダンボールに滑り込む動画も、実は追いかけっこから生まれました。段ボール箱はもともと好きだったので、空き箱が出るたびにまるにあげていたのですが、追いかけっこの最中に床に置きっぱなしになっている段ボール箱を見つけ、逃げ込んだのが最初でした。床がつるつるしたフローリングなので、思いの他よく滑ります。それを何度か繰り返すうち、まるもコツをつかんだらしく、滑り込む技術にどんどん磨きがかかっていきました。より速く、より遠く、ロケットのように滑っていきます。やがて単なる避難場所としてだけでなく、滑り込む行為自体を楽しむようになったようです。

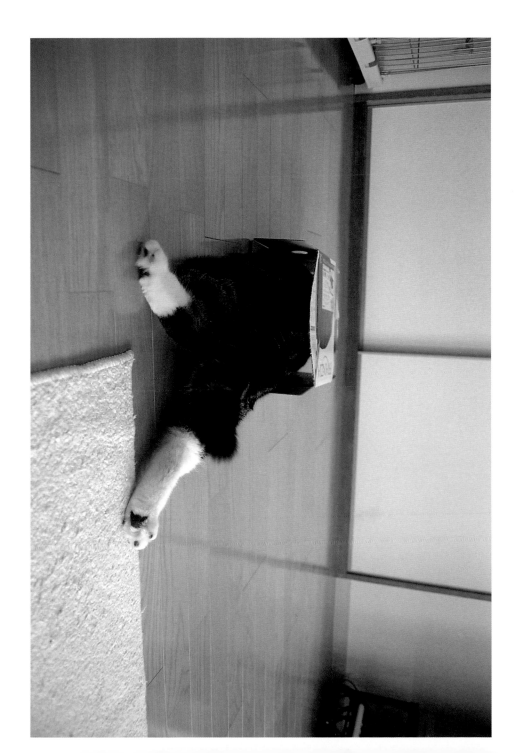

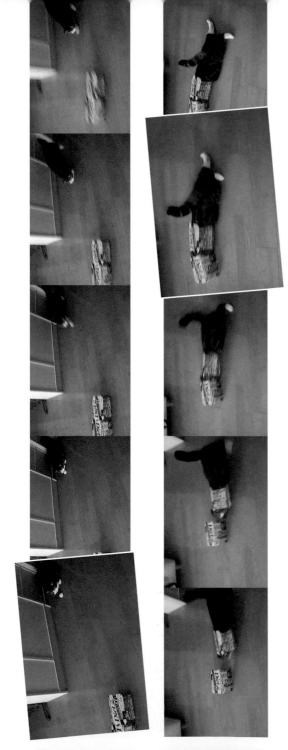

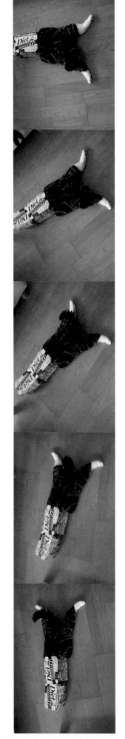

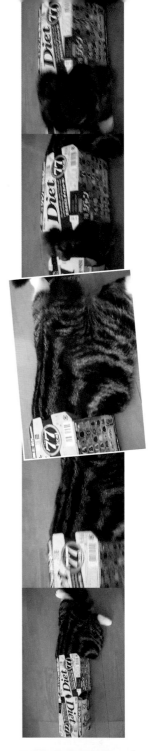

(M) The Sliding Box Cat　すべり込む猫

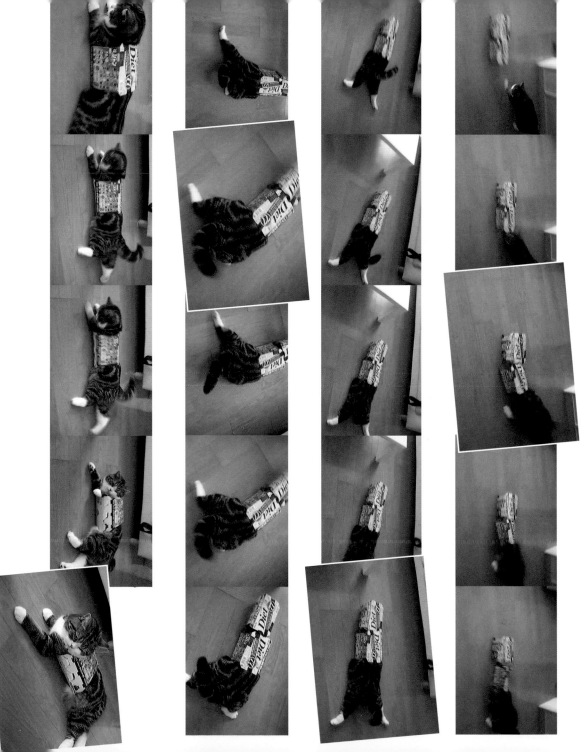

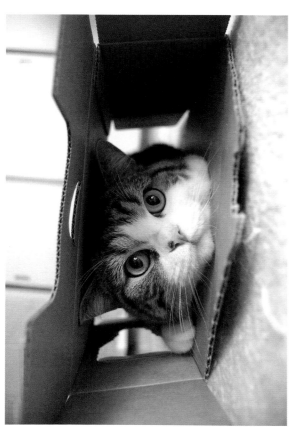

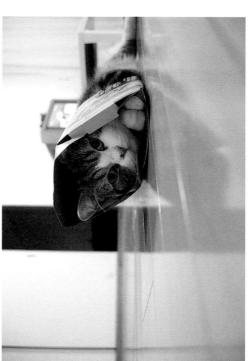

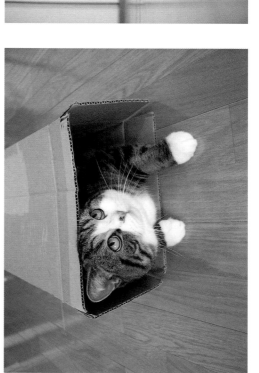

I will slide into any box. What matters is to jump-start.

どんな箱でも、とりあえず滑り込みますよ。大事なのは勢いです。

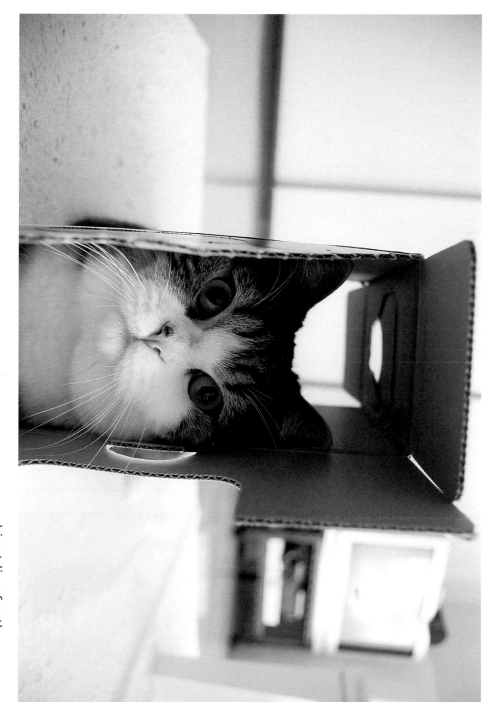

I just live for the moment!

後先なんて考えません。

M. As long as there is a box そこに箱がある限り。 Part 1

A beer box is my favorite.
ビールの箱がお気に入りですよ。

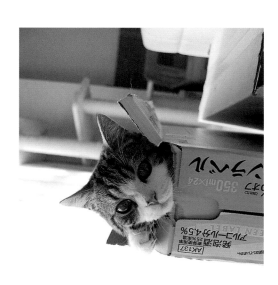

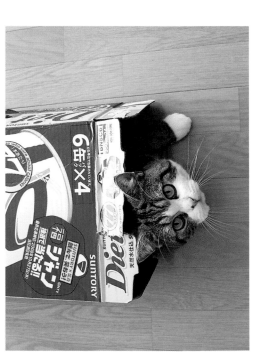

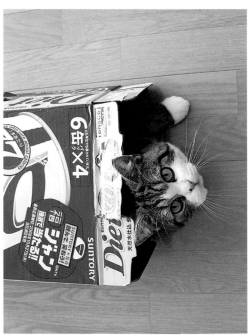

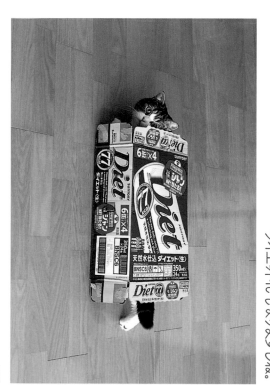

It's good exercise! (And for diet, too?)

ダイエットにもなりますしね。

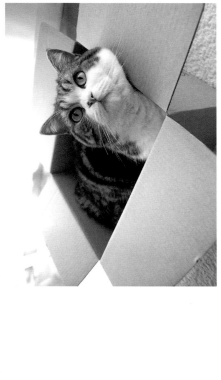

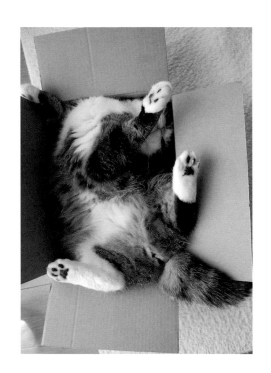

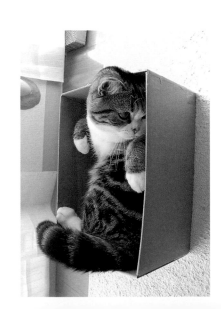

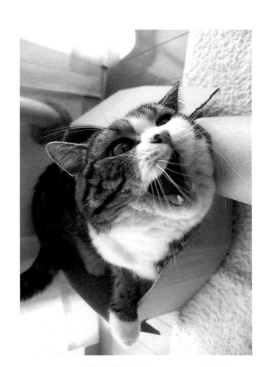

M As long as there is a box . . . そこに箱がある限り。 Part 2

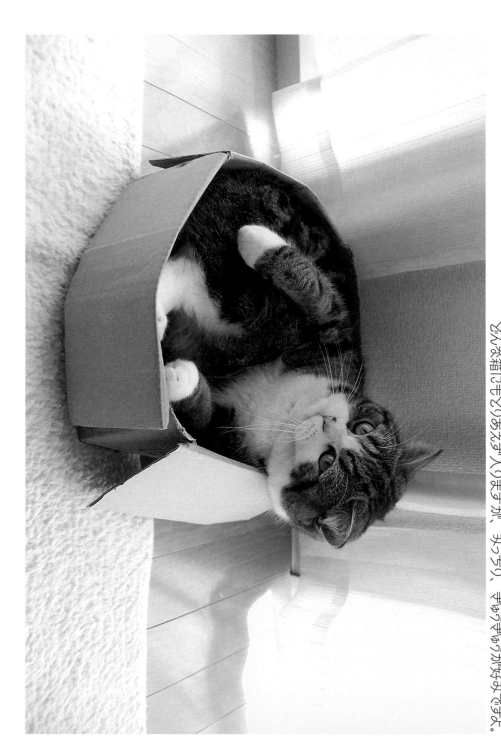

I try boxes of all shapes, and I especially love to be squeezed in.

どんな箱にもとりあえず入りますが、みっちり、ぎゅうぎゅうが好みです。

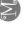 Even in a trash box . . . ゴミ箱にも入ります。

As soon as I take the trash out, Maru gets in.

ゴミを捨てようとって中身を取り出すと、まるがすかさずINします。

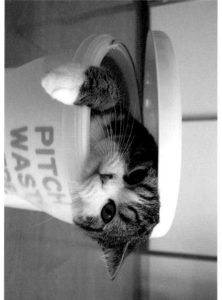

I love doing whatever I'm told not to!

ダメと言われるとますます入りたくなります。

Bags are no exception! 袋にだって入ります。

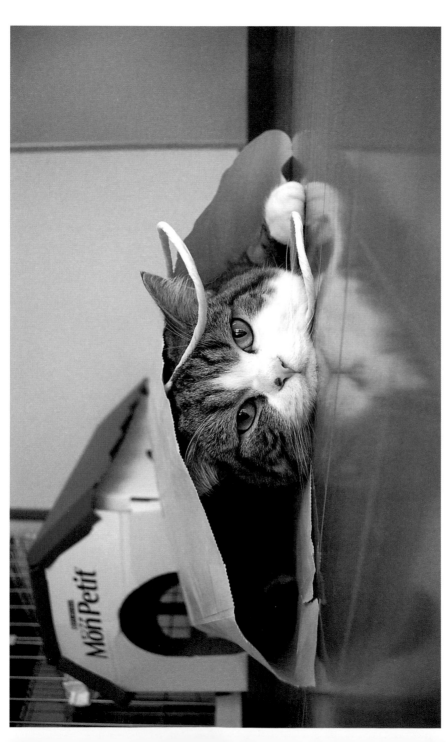

He rushes recklessly for boxes but not for paper bags at all. He peers very cautiously into a bag before entering. When he was little, he curiously put his head into the plastic bag and his nose got bitten by a bug. He was so surprised and rushed out in reverse, scratching his nose with both hands. It was a tiny black insect, and his nose didn't get swollen. Maybe he still remembers that frightening event. . . .

箱には猪突猛進のまるさんですが、紙袋に入る時は慎重派。最初は恐る恐る入り、安全を確かめてから入ります。小さい頃、コンビニの袋に顔を突っ込んで、鼻面を虫に噛まれたのが原因かも。鼻を両手でこすりながら、バックで慌てて出てきたことがありました。ごくごく小さな黒い虫で、腫れたりとかはなかったのですが、かなり驚いたようです。

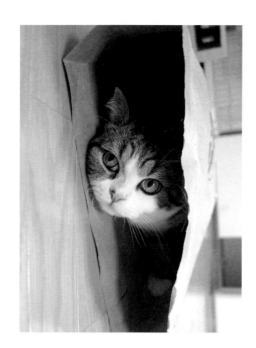

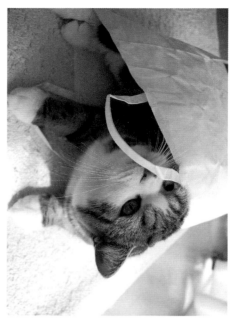

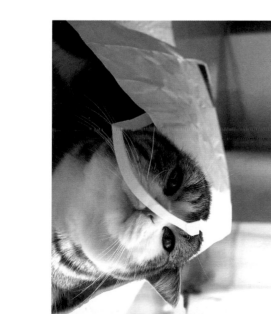

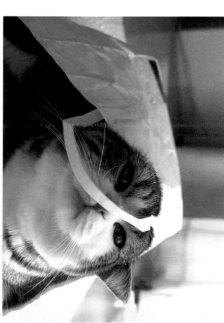

I know there's a demon hiding in a bag.

袋には魔物が潜んでますよ?

January 9, 2008

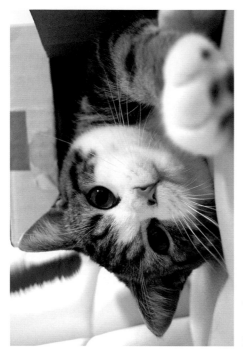

Hmmph.
ばあー。

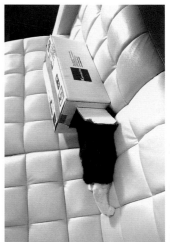

This cardboard house.
このダンボールハウス。

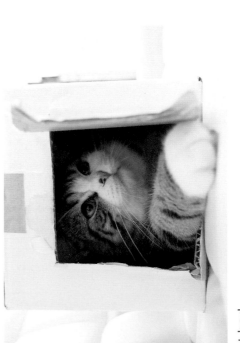

Not bad.
なかなか川いですよ、

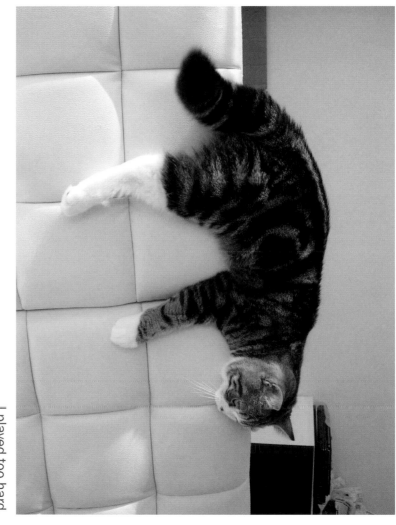

I played too hard.
I need a little break now.

遊び疲れました。
ちょっと休憩。

February 15, 2008

Nyah, you stuck in there and can't get out, can you?
[やーい、入っちゃはいいけど。出てこられないんでしょう]

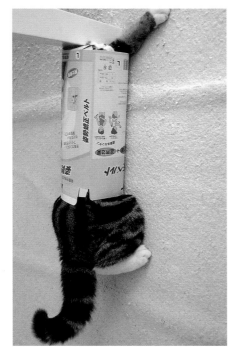

Are you kidding?
Watch!

おかしなことを言う同居人ですね。

見ててくださいよ。

February 2, 2008

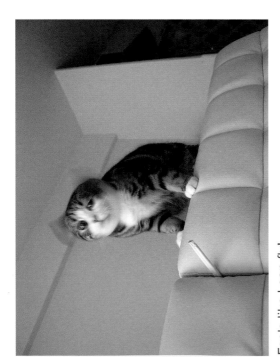

Feels like I can fly!

モラリして飛べそうです。

Ready
ラリャ

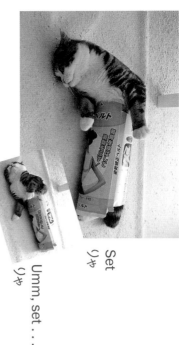

Set
リャ

Umm, set . . .
リャ

Go!
りゃー!

See?
どうです。

Umm . . . You looked so desperate.
「──ものすごい必死でした」

Anyway, I kinda like . . .
それにしても、
それがおかしいですね

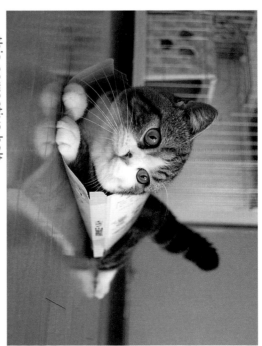

. . . this corrective belt.
この矯正ベルト。

It stretches my back.
背筋が伸びます。

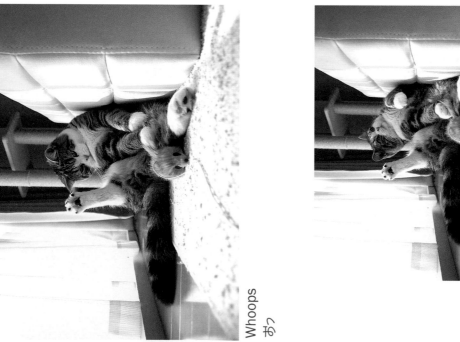

Whoops
あっ

daisy!
にゃ

ん
a

Hey, Maru!
「まるさ〜ん」

Yes?
はい

And . . . ?
はい

What?
えんですか?

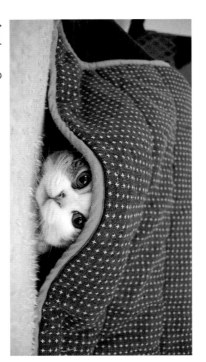

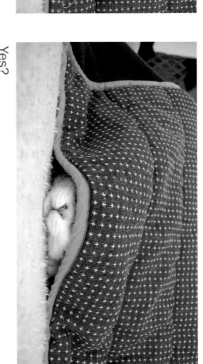

Nothing.
「えんでもありません」

Please don't call me for
nothing!
用もないのに呼ばないでください!!

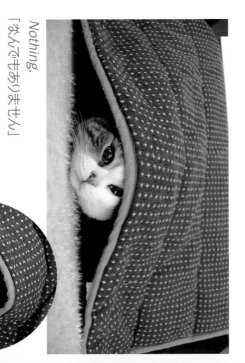

Sliding Cat's Secret

The famous video "The Sliding Box Cat" was originally shot for some YouTube contest entry. I wanted to capture Maru's sliding moments, but couldn't do it if we were chasing each other. So in order to capture him on video, I held the camera in my right hand and moved the box little by little with my left hand to get his attention. It worked well. The trick was to open both sides of the box so that he could see the other side and to move the box away from him slowly.

There's no secret to how I usually shoot Maru—we just play together and have fun. Sometimes I use a toy to get his attention, but never food. It looked like he invented the game and played as he liked. Every time I shoot videos of him, I have to try hard not to laugh.

Cameras:

Nikon D40

Nikon is my main camera now.
Main lens: AF-S NIKKOR 18-55mm
Sigma 50mm F1.4 EX DC HSM for Nikon

CASIO EXILIM
EX-Z1000

KDDI cell phone

I used "au" cell phone in the early days. Now, I use Casio for taking videos.

Maru and play

Maru loves to play, but he seems to get tired of the plantlike stick toy lately. He comes to me and mews like "I'm bored! Play with me," but if I show him the wrong toy, he looks away. I always puzzle over how to please him more.

まると遊び

まるはとっても遊び好き。ですが最近はまたびの頃のように、猫じゃらしを振ってただけでは遊んでくれません。足元に来て「退屈だー」、遊ベーと騒ぐのでおもちゃを見せても、それでは遊びたくない、とそっぽを向かれることも。なので同居人は、どうやったらまるに満足いただけるかと、日々頭を悩ませています。

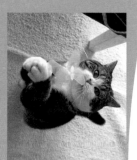

Maybe he's just at a difficult age.

難しいお年頃ですよ。

Once he's in his playing mode, however, he never wants to stop! ただひとたび遊びのスイッチが入ると、どこまでも調子に乗る一面も。

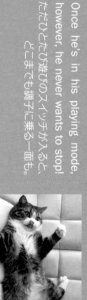

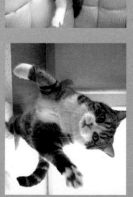

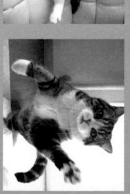

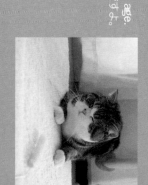

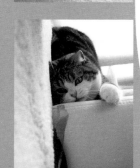

Ⓜ Rubber-Faced Maru まるの百面相

His face is round and big, but it's mostly
fur. If I stroke his fur, it will change like this.

顔が丸い、大きいとよく言われますが、実はほとんど毛です。
手で毛を撫でつけるとこうなります。

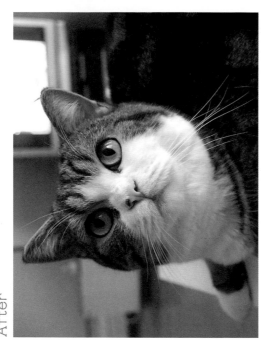

After

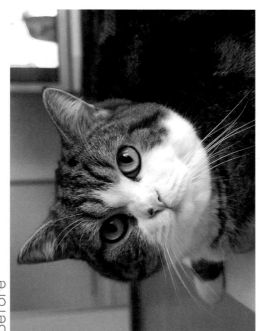

Before

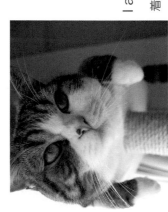

I am said to be a man wearing heavy clothes. . . .

着膨れするタイプと言われます。

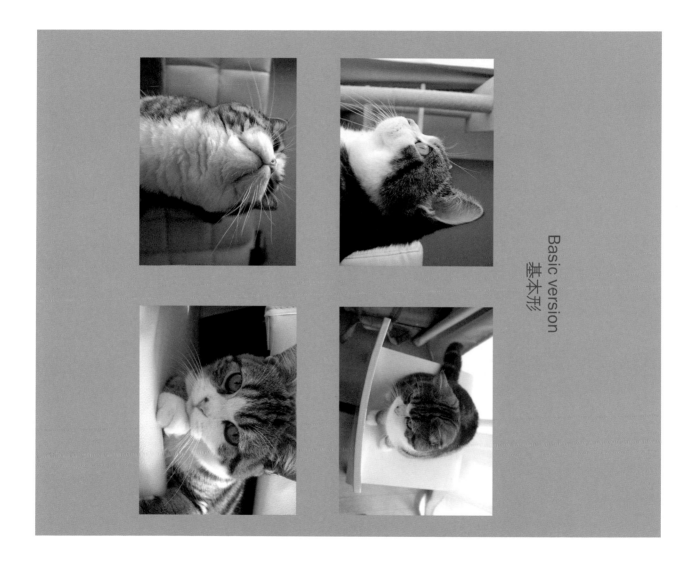

Basic version
基本形

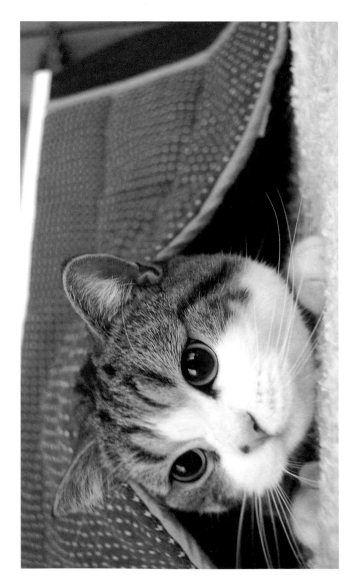

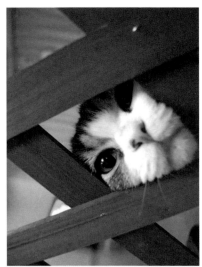

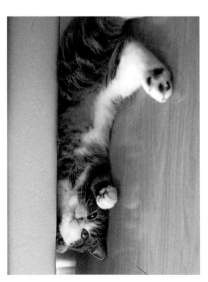

Lovely Maru ラブリーまるさん

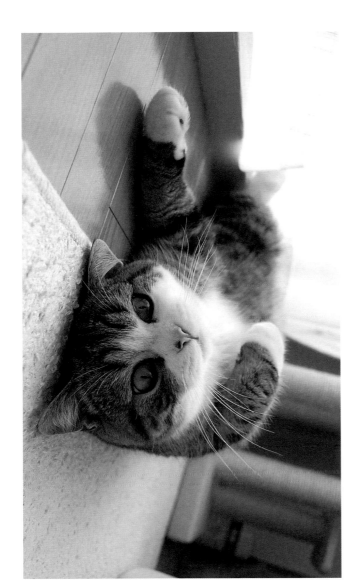

I'm usually ccnsidered very cute.
普段はとっても可愛いと評判ですみ。

Ⓜ Maru's costumes and impersonations まるのコスプレ & ものまね

Four selected costumes コスプレ4連発

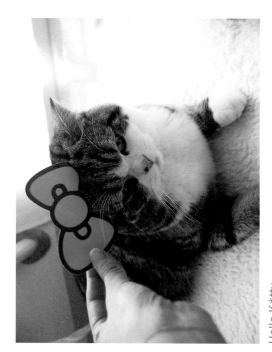

Hello K*tty
キロィちゃん

Little Red Riding Hood
赤ずきんちゃん

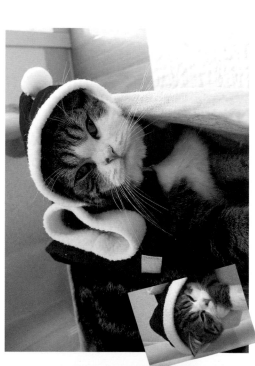

Santa Claus This is from last year and doesn't fit anymore.....
サンタクロース ※去年の衣装が入りません

Transformed raccoon
変身タヌキ

46

Four selected impersonations　ものまね4連発

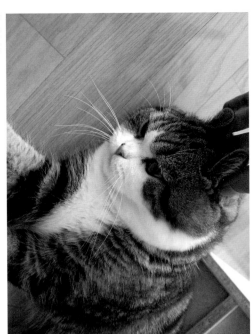

Rabbit!
うさぎ！

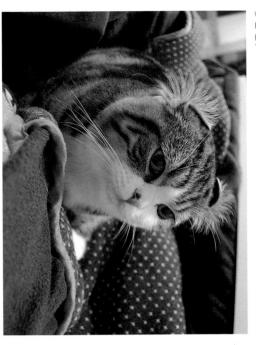

Ballerina
バレリーナ

Owl meets a tough enemy
強い敵と出会ったフクロウ

Scottish Fold
スコティッシュフォールド

Wait, that's what I am!
※いや、スコですから

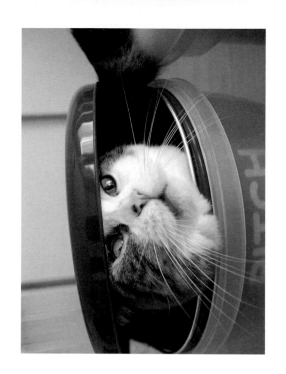

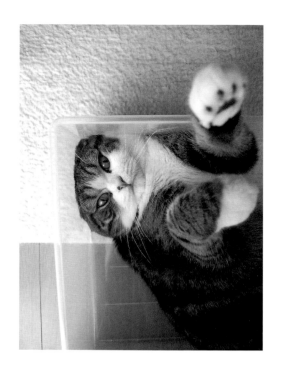

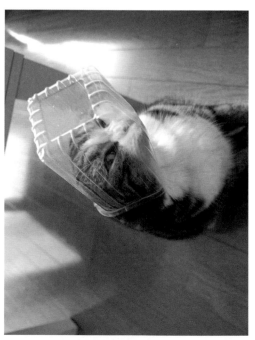

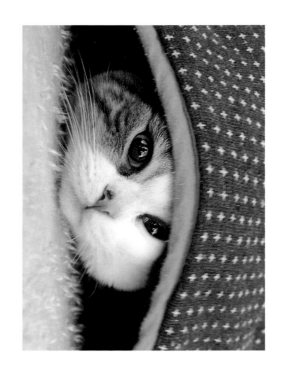
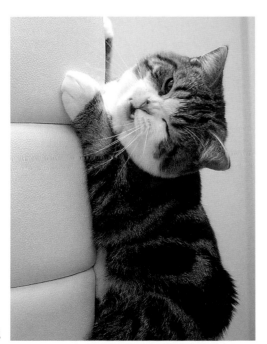
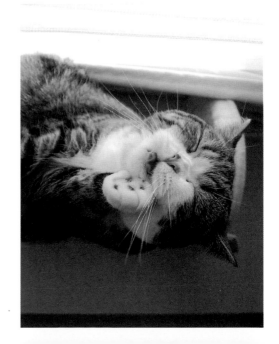

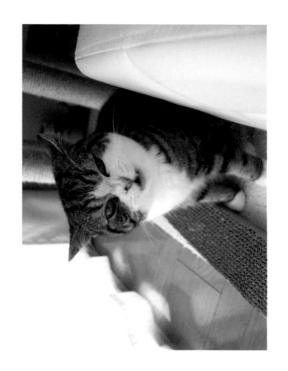

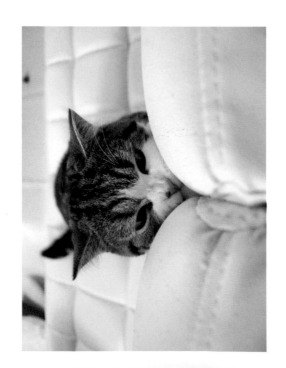

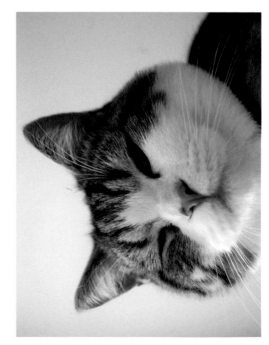

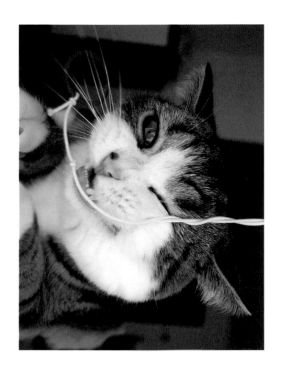

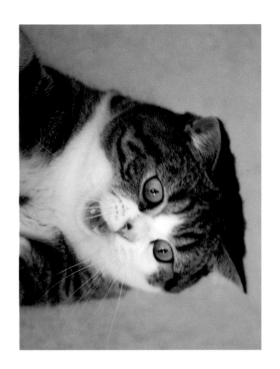

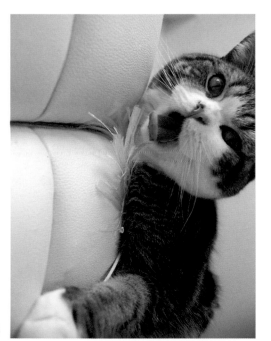

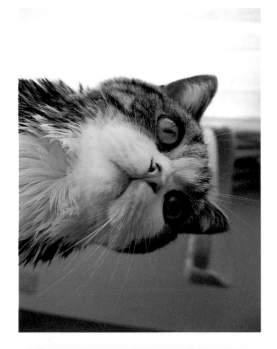

May 19, 2008

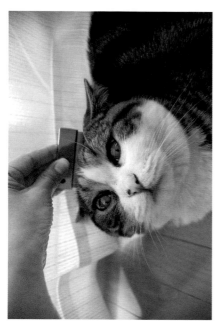

What are you doing?
何やってるんですか？
I'm giving you brushing.
「何って、ブラッシングですよ」

Really? For some reason
そうですか、でもその割には . . . なんだか

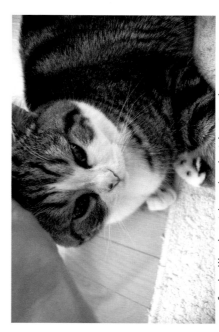

Well, I'm getting bored, so let's do it right then.
「そろそろ飽きたんで、ちゃんとやりましょうかね」

. . . feels like I get laughed at instead.
. . . 笑われてる気がするんですけど。

What's this?
なんですか、これは。

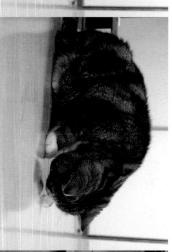

Hmm hmm (sniffing)
ふんふん

Wow, it's cold!
ラわっ、ちめたい!

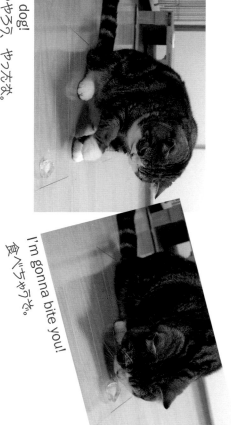

You dog!
このヤロウ、やったな。

I'm gonna bite you!
食べちゃうぞ。

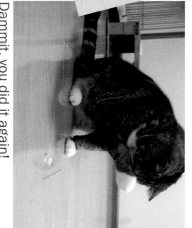

Dammit, you did it again!
またやられた!!

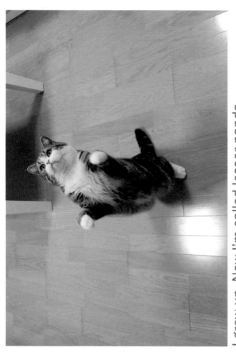

I grew up. Now I'm called lesser panda.
大きくなってからはレッサーパンダ"

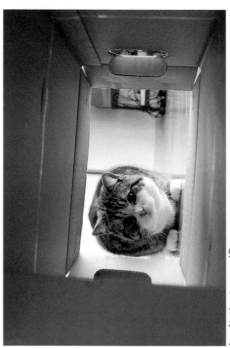

Isn't that cruel?
ひどくないですか?

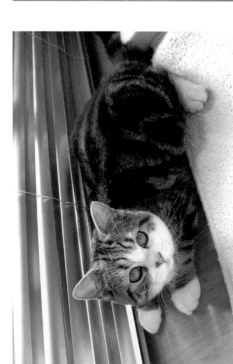

When I was little, I was a chipmunk.
チビの頃はシマリス

Even called a gigantic slug sometimes.
時々、巨大なめくじと言われます。

June 6, 2008

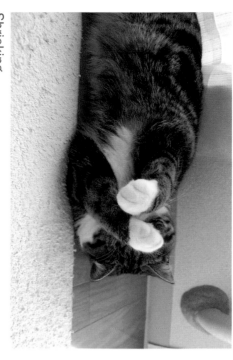

Shrieking . . .
キャッ、

and peeping . . .
とか言いながら見てる人

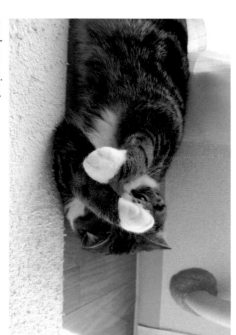

Just kidding!
なんちゃってー。

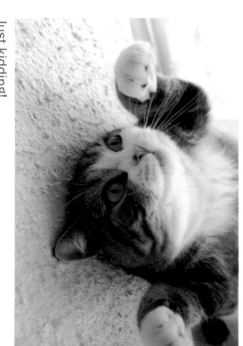

June 11, 2008

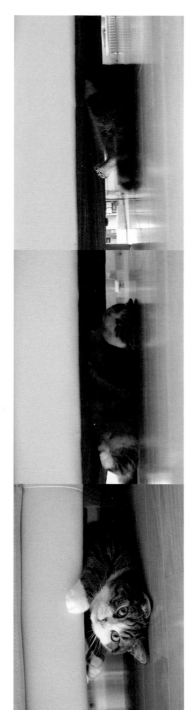

Under the sofa . . .
ソファの下は。

like this
こうやって

roll over
ひっくり返って

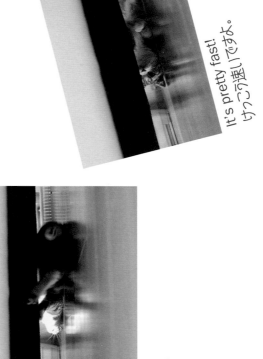

It's pretty fast!
けっこう速いですよ。

and go
移動します。

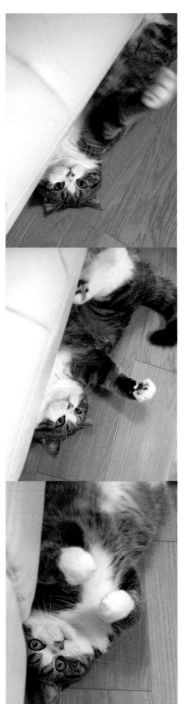

Someone is making a noise at my feet.
「なんだか足元が騒々しいですね」

Quiet, please. I'm watching TV.
「テレビを観ているんですよ。
お静かにお願いします」

I'm t o red. Let's play!
退屈です。遊んでください。

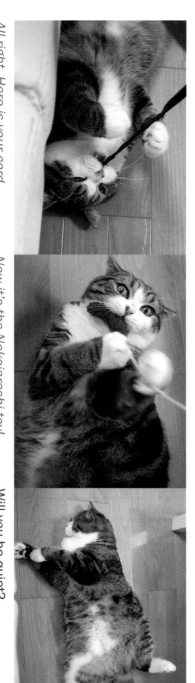

All right. Here is your cord.
「しょうがないですね、
それでは紐をどうぞ」

Now it's the Nekojarashi toy!
「次はねこじゃらしですよ」

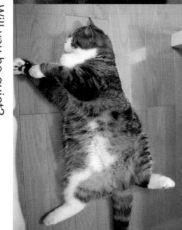

Will you be quiet?
I'm going to bed now.
もう寝るので静かにしてください。
「・・・・・・。」

・・・（silence）・・・

An Uncharacteristic Cat

When I was growing up my grandmother had a cat, but Maru totally changed my view of what a cat would be like. The cat at grandma's house liked warm and soft places, loved to be held, and would climb up on my lap like a baby. But he'd never get close to somebody he didn't like. That was my impression of a cat. Maru is not a good one for fawning. He doesn't like anything warm, maybe because he has thick fur. He loves to lie down on a cold, hard, and smooth-surface wooden floor. He doesn't care about whoever comes to our house and doesn't snuggle or purr with them either. He always acts cool and goes his own way. He hates to be held and never jumps on my lap, except when he awakes. Then he becomes quite huggy and purrs like a cat! My image of a cat doesn't apply to Maru very often.

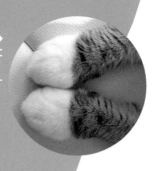

◆ Hands
My proud white gloves
自慢の手袋ですよ。

◆ Tail
A little short tail
しっぽはちょっと短め。

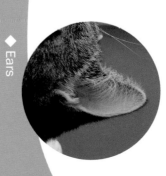

◆ Ears
Prick-eared Scottish Fold
立ち耳スコです。

◆ Legs
I'm wearing a pair of socks,
too.
ソックスも履いてますよ。

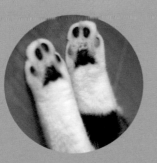

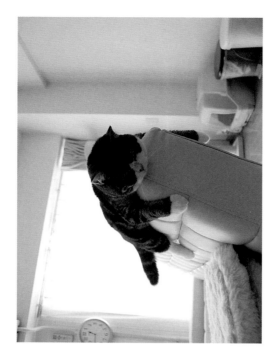

This is the proper way to use a sofa.
これが正しいソファの使い方ですよ？

Snapshots スナップショット

Maru's daily life

His hobbies are eating and sleeping. Basically he's lazy and spends his day being laid-back and easygoing. But when it comes to play, he gets really serious. I hope you enjoy watching Maru, who is adorable sometimes, at other times has a bad attitude, loves adventure, and lives his life with heart and soul every day!

まるさんの日々

趣味は食べることと寝ること。基本的にはぐうたらで、毎日のんびり、ゆったりと暮らしてます。でも遊ぶ時はいつも真剣。時に愛らしく、時にふてぶてしく。冒険心を忘れずに、毎日一生懸命、真剣に生きるまるさんの姿をお楽しみください。

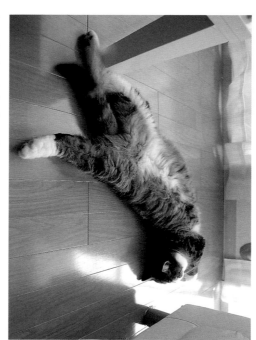

I can't stand the heat!
暑くてかないません。

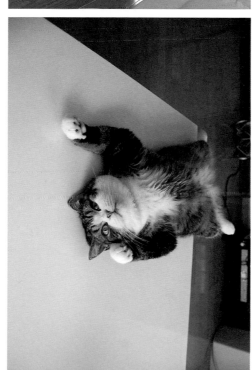

This table is my bed.
テーブルはぼくのベッドです。

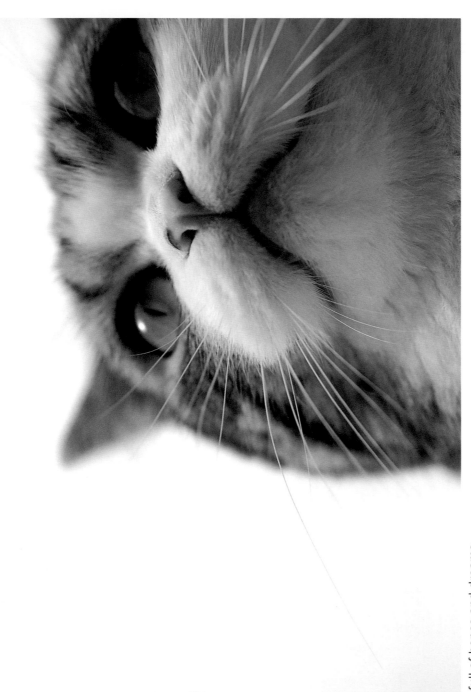

I am full of hopes and dreams.
夢も希望も持ってますよ。

Cleaning my face carefully is the foundation of being cool.

洗顔は念入りに。 男前の基本ですよ。

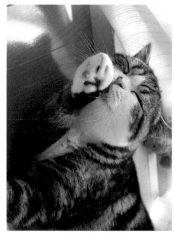

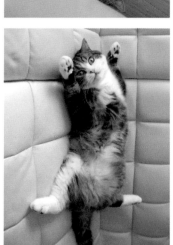

Lying on my back is so relaxing.

仰向け寝は楽ちんです。

How many balloons do I need to fly?
風船なん個で空飛べますか?

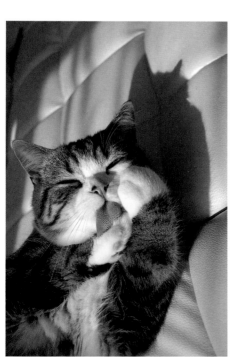

Bleah!!
あつかんべー。

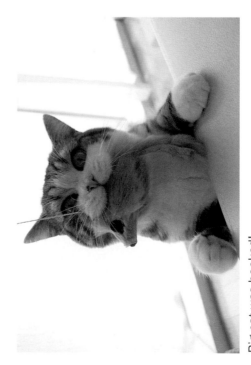

Big cat was hooked!
おつきな猫が釣れましたよ。

64

How do I look with this crab-shell hat?

カニ甲羅ハット。似合いますか?

I'm taking aim at my prey.

狙ってますぉ。

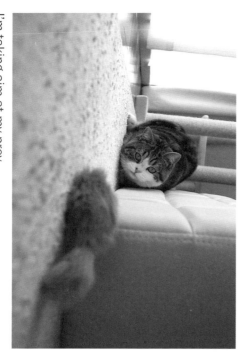

I don't like the collar; I will take it off right away.

首輪はすぐに外しちゃいます。

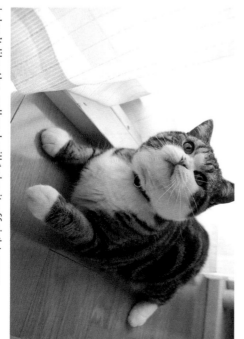

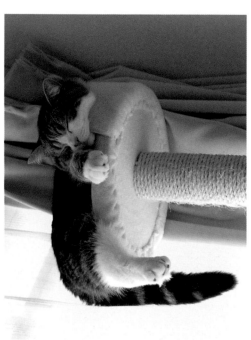

ZZZ
ZZZ 。

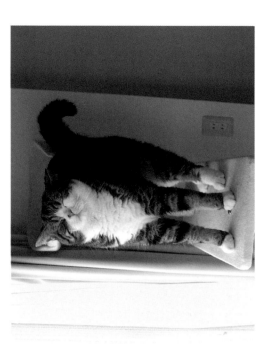

Oh, I slept very well!
あーよく寝た!

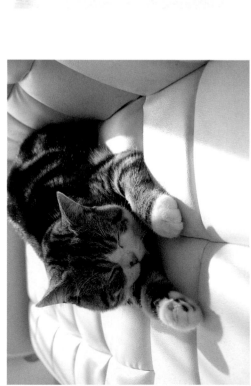

Grooming before a nap.
お昼寝前のモゾくろい。

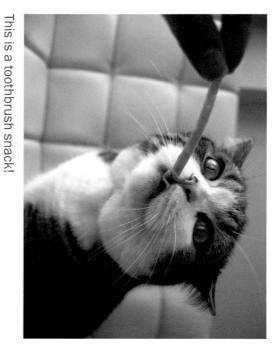

This is a toothbrush snack!
歯みがきもできるおやつなんだって。

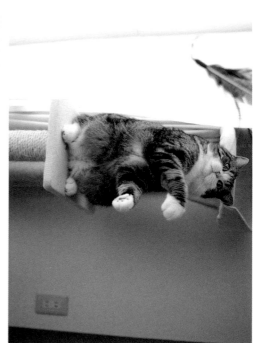

Well, let's play some more.
さて、もうひと遊び。

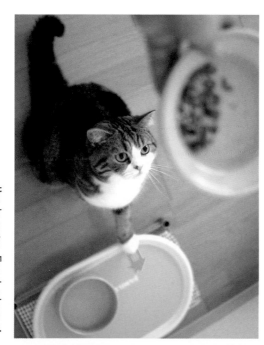

I'm hungry. Food, please!
お腹が空きました。ご飯はここですよ。

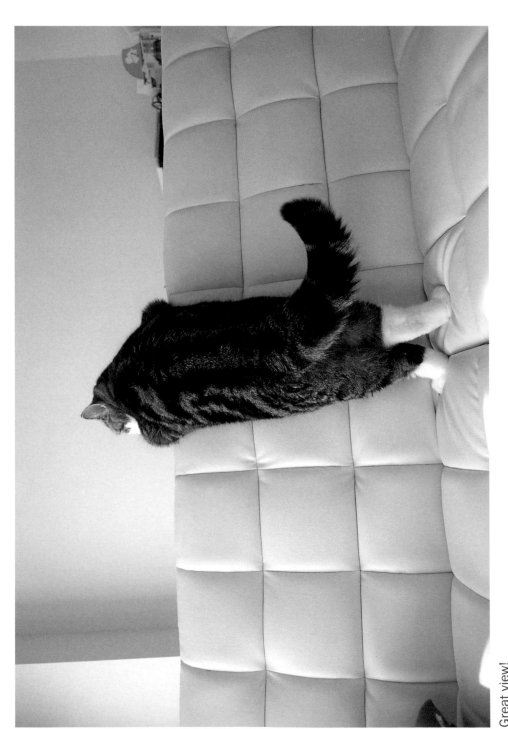

Great view!
いい眺めですよ。

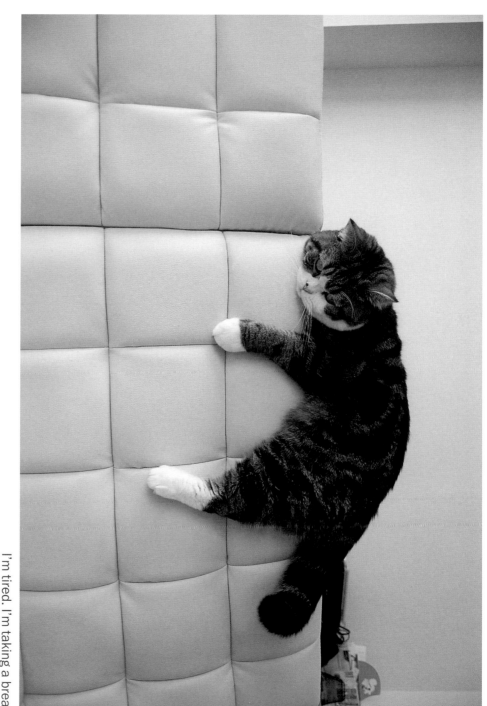

I'm tired. I'm taking a break.

疲れたのでちょっと休憩。

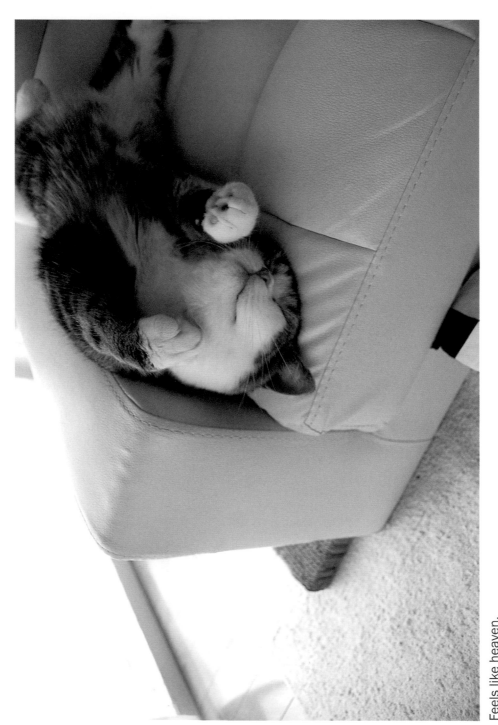

Feels like heaven.

極楽ですみ。

72

A little break during grooming.
モブくろい中の一休み。

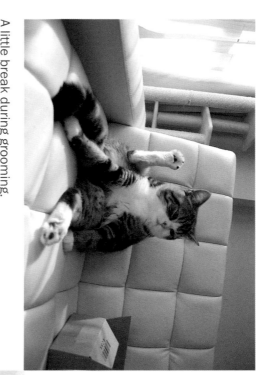

I like this spot even though my body sticks out.
いっぱいはみ出てもここぺんがお気に入り。

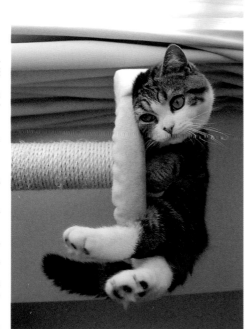

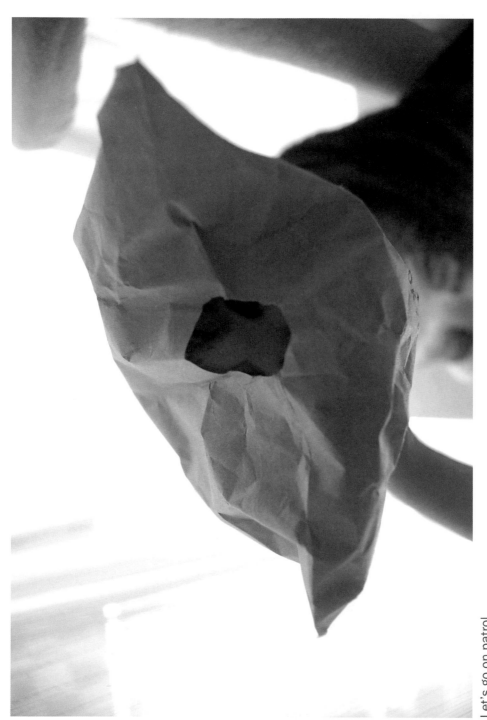

Let's go on patrol.
さて、パトロールにでも出かけますか。

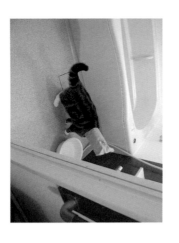

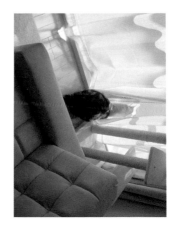

All serene!
どこも異常ありません。

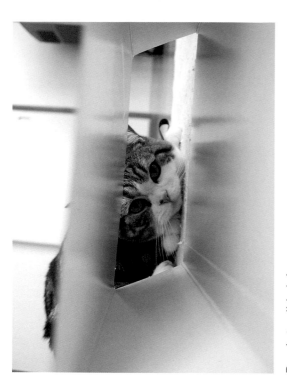

Ready to slide in!
滑り込みますよ。

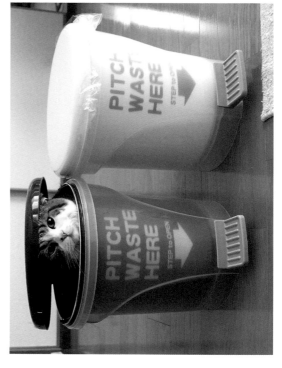

I like the brown one better.
茶色い方が好きです。

My favorite chair.
お気に入りの椅子 ♪

7-4

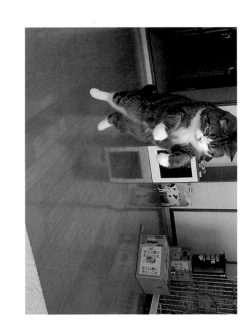

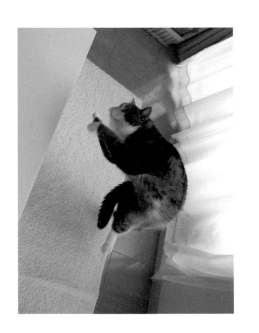

Watch, I can jump, too!
ジャンプだって できます。

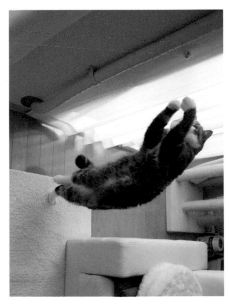

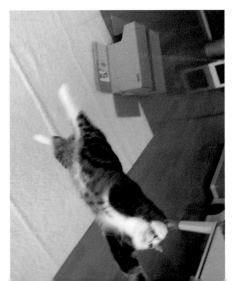

August 27, 2008

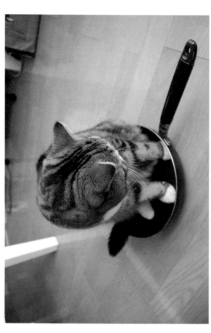

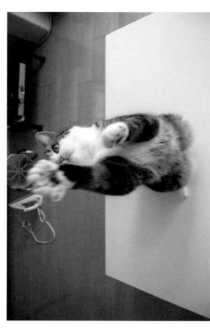

Boxing training to lose weight.
ボクササイズでダイエットです。

What is this?
これは何ですか?

It's an old frying pan. You can have it,
'cause I got a new one.
「それは古いフライパンですよ。
買い換えたので[まるさん]にあげます」

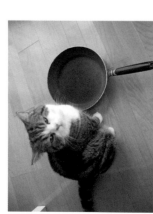

Yo, fried cat?! How do you like it?
「よう、フライパンねこ!どうですか、入り心地は」

Umm, could be better.
ラーん、いまいちですね……。

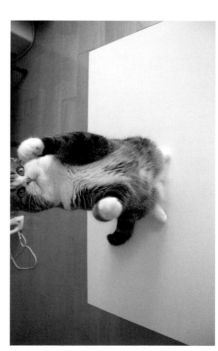

What are you doing?
「何してるんですか?」

Actually, I'm quite busy now.
そんなことより、今ちょっと忙しいので。

September 1, 2008

It's fun playing with a towel.
手ぬぐいで遊んでます♪。

You looked scared when you saw it for the first time.
Can I borrow it now?
「初めて見る手ぬぐいに、最初ちょっとビビってましたね。
今度は私にも遊ばせてください♪」

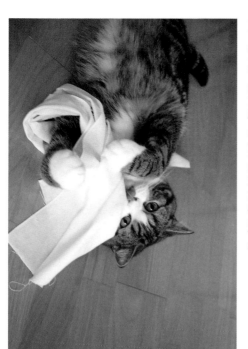

Sure. Be my guest!
いいですよ。こんな手ぬぐいでよかったらどうぞ。

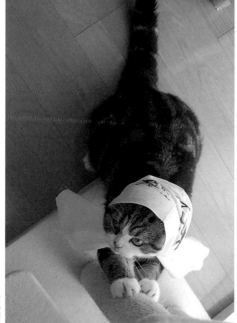

. . . NOT!!
——って、まったくも〜!
プチ

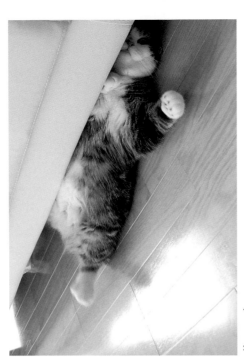

I'm serious.
もちろん隠れてますよ。

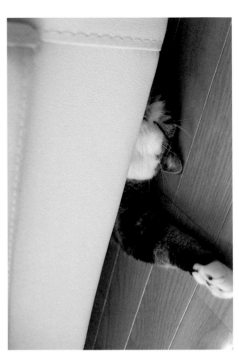

In fact, you are sleeping.
「──寝てますが？」

September 5, 2008

Hey, Maru, what are you doing there?
[まるさん、まるさん、そんなところで何やってるんですか!?]

Shh! I'm hiding out.
しっ! 隠れてる最中ですよ。

You must be kidding.
[まさか、それも──?]

78

September 21, 2008

You came to our house exactly one year ago.
「今日できまるさんが来てちょうど1年ですね」

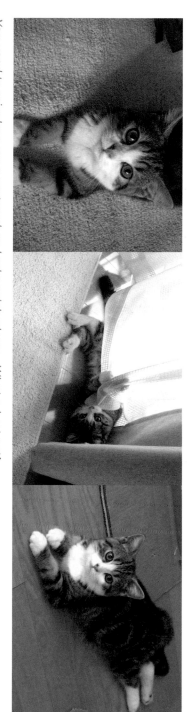

You used to misplace your anger when I admonished you. What a brat cat!
「叱れば逆ギレする、とんがいたず坊主でした」

Well, didn't you say I was adorable when I was little?
「子どもの頃は可愛かったのに」 と言ったのは。

誰ですか？

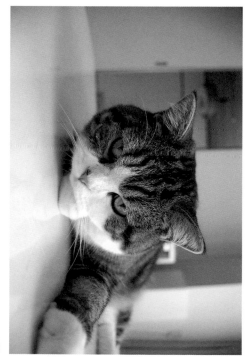

79

October 2, 2008

Maru, there's something I didn't tell you.
「実は、まるさんに内緒にしていたことがあるんです」

Ta-dah! I grew cat grass for you.
Last time you spoiled it so fast.
「じゃーん。内緒でこんなものを育ててみました。
この間のは、あっという間にだめになってしまいましたからね」

Hey, Maru, you are already
squashing it with your face.
「まるさん、
顔で押し潰してますー――」

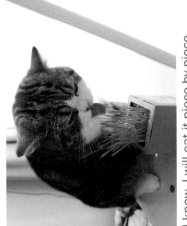

I know, I will eat it piece by piece.
わかってますよ。一本ずつ食べればいいんでしょ。

Oh, no, you ate all my food, did you?
ますか、僕のカリカリを食べたんじゃないでしょうね

Not that! Well, it's about
「違います。実は――――」

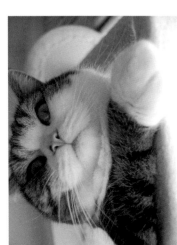

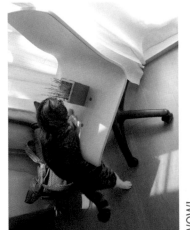

WOW!
うわあー!!

Don't waste it this time.
「今度は大事にしてくださいよ」

80

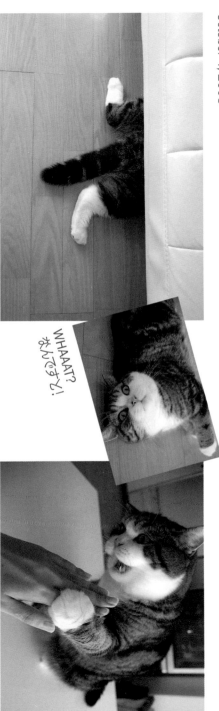

Hey, listen!
Your video was on the air last night!

「まろさん、そんなことやってる場合じゃないですよ。
昨日の夜、テレビでまろさんの動画が流れたそうですよ」

WHAAAT?
なんですと！

How come you didn't tell me in advance?
どうして先に教えてくれなかったんですかー!!

Please don't get upset.
I didn't know either . . .

「そんなに怒らないでください。
私だって知らなかったんですから」

It's not fair.
If I knew, I would've washed my face
more carefully . . .

――あんまりです。そうとわかっていたら、
もっとちゃんと顔を洗ったのに。

Ummm, that's not the point . . .
「そういう問題ではありません――」

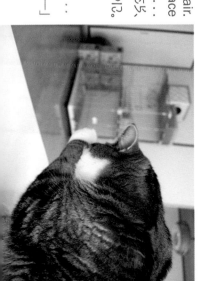

Ⓜ Moving まるさんの引っ越し

The first move with Maru was in July 2009. It was very challenging for us to relocate with Maru. First of all, there are few houses available that accept pets, especially a cat. Even though we managed to find one after all, we still had lots of concerns about Maru. To be well prepared for the move, we asked for some advice from a veterinarian.

On moving day, I kept him in the bathroom with a sand tray while taking all the stuff out. Then we traveled by bullet train. We purchased the additional ticket for Maru's carry bag at the station. Maru was calm and well behaved all the way on the train. After arriving at the new house, Maru slowly got down into low gear and started checking out the unfamiliar territory. He looked OK, but in fact he must've been very excited as he was breathing with his mouth open. On the next day, we were relieved to see him lying down on the floor just like he does normally.

Great job, Maru!

2009年7月、まるさんと一緒に初めての引っ越し。猫を連れての引っ越しは本当に大変でした。まずは物件探しから困難を極めます。ペット可の物件でも、多くは小型犬のみ。そして部屋が見つかってからも心配事は尽きません。事前にかかりつけの獣医さんからアドバイスをもらいつつの引っ越し準備となりました。

引っ越し当日は、まるさんには簡易トイレと一緒にお風呂場で待機してもらい、荷物の搬出。それが終わると新幹線に乗っての長距離移動。まるさんをキャリーバッグに入れ、駅で手荷物チケットを購入して乗車します。車中でのまるさんは騒ぐこともなく、比較的落ち着いていました。そして新居へ。見慣れない景色に、ぼふ、ぶ前進でひとつひとつとチェックしていきます。落ち着いているように見えてもやはり興奮していたらしく、ロで息をする場面もあり心配しましたが、次の日には仰向けに寝て転がって、すっかりいつものまるさんに。どうもお疲れさまでした！

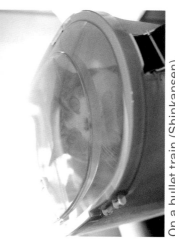

On a bullet train (Shinkansen).

新幹線車内。

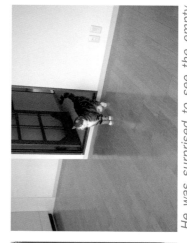

He was surprised to see the empty room.

何もない部屋にびっくりするまる。

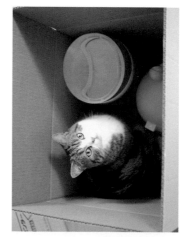

I enjoyed packing.

荷造りは楽しかったですよ。

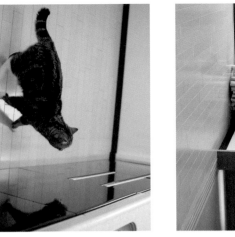
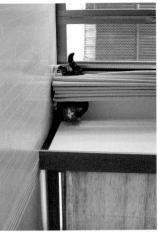

Checking the new house on high alert.
警戒しながら新居チェック。

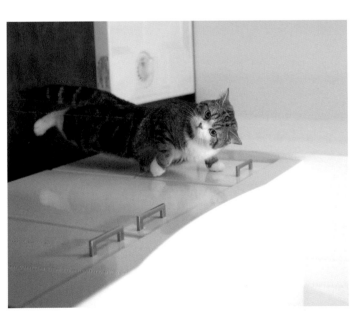

Maru is at ease and gets cozy.
安心して寛ぐまる。

Maru's Likes and Dislikes

Likes:

Tuna, sasami (chicken-breast tender). He normally eats a combination of wet and dry food, but a few pieces of raw tuna or broiled sasami for toppings makes him very happy!

For playing: cardboard boxes. He seems to prefer cardboard boxes over paper bags. And bugs—especially flying ones. Whenever I found a bug flying in the house, I called "Maru!" So now he dashes toward me with mewing, mewing, and mewing. His favorite place is a hard, slippery surface—bathtub, wash basin, and inside of the washing machine.

Dislikes:

Milk. Also: Gizzards. When he smells milk, he starts the gesture of digging. I sometimes cook a meal for him, but if he notices a hint of gizzard, he doesn't even touch it. Basically he doesn't like anything warm. He likes anything that is refrigerated, even in winter. And he doesn't like to be held, either.

Likes

Mouse toy

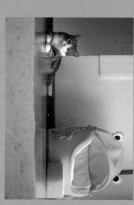

He walks around with it every night.

ねずみのおもちゃ一夜な夜なひとりで銜えて
歩くくらい好き。

Panda toy

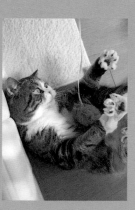

He plays with it sometimes.

パンダのおもちゃときどき遊ぶ程
度に好き。

Dragonfly toy

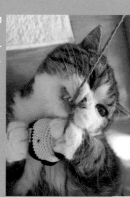

He played hard with it till it
broke.

トンボのおもちゃ一遊び過ぎて壊れ
ちゃった。

Dislikes

Frog-shaped bed

He never used it.

カエルのベッド
一度も寝たことありません。

Caterpillar toy

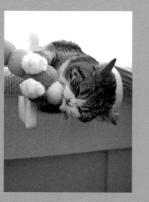

Almost ignores it.

イモムシのおもちゃほぼ無視。

Hedgehog named Harry

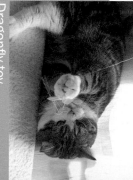

Completely ignores.

完全に無視。

NOTE: It's based on individual cat preferences. (注）あくまでも個猫的な好みによるものです。

ⓂⓄ Maru's favorite territories まるさんのお気に入りテリトリー

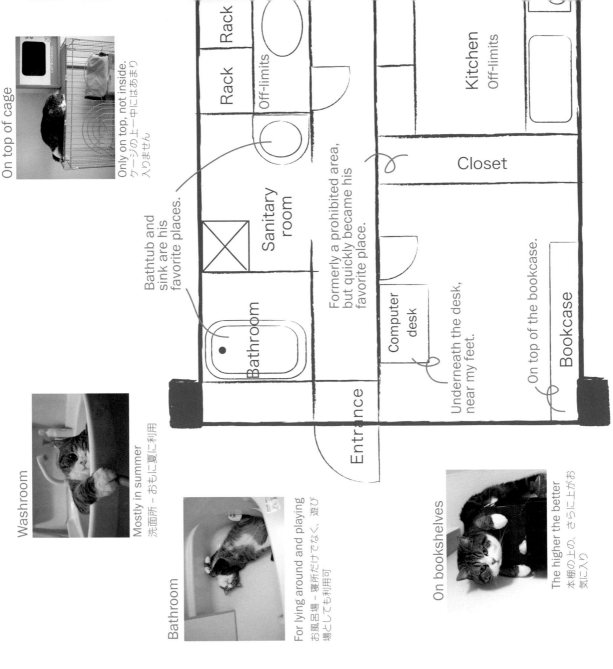

On top of cage

Only on top, not inside.
ケージの上へ一中にははまり
入りません

Washroom

Mostly in summer
洗面所 - おもに夏に利用

Bathroom

For lying around and playing
お風呂場 - 寝所だけでなく、遊び
場としても利用可

On bookshelves

The higher the better
本棚の上の、さらに上がお
気に入り

Floor plan labels

Rack

Rack

Rack

Off-limits

Kitchen
Off-limits

Bathtub and
sink are his
favorite places.

Sanitary
room

Closet

Formerly a prohibited area,
but quickly became his
favorite place.

Bathroom

Computer
desk

Underneath the desk,
near my feet.

On top of the bookcase.

Bookcase

Entrance

Maru's cage

Inside the closet is also his favorite.

On top of the cage is his favorite.

Japanese-style

Another popular place is window shelves.

Shelves

Lattice

This is Maru's main stage where famous videos such as "Intensive Training Cat" and "The Big Box and Maru" were shot.

Maru's dinner area

Maru made the kitchen table his bed except for my meal time.

He plays by sliding under the couch or rests on top of it.

Maru's bathroom

Couch

Kitchen table

TV set

He couldn't even climb up the tower at first.

Cat tower

Veranda

Tatami mat room's window shelves

He sleeps here most of the time.

和室 窓辺の棚一年中利用。夜
はだいたいここで寝ています

On the table

Through his efforts, he is now allowed to be on it except during housemate's meal.

テーブルの上努力により、同居人
の食事時以外はOKに

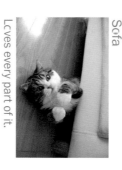

Sofa

Loves every part of it.

ソファー背もたれから隙間まで、無
駄なく利用

Cat tower

Mostly in winter.

キャットタワー
おもに冬に利用

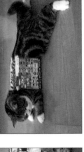

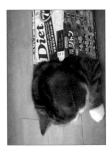
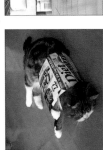

Ⓜ Maru's popular videos まるの人気動画

Intensive Training Anything for the perfect slide. (Actually he is just playing.)

Posted on October 25, 2008 01:32

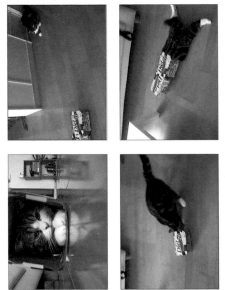

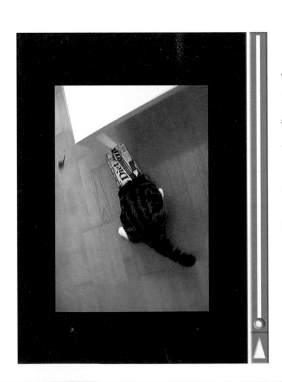

A viral-viewing hit! Although not the first to feature a sliding cat, this winning video shows Maru sliding through two boxes. Not content with merely being fully enclosed sliding into the first, he continues on through to the next. Cool as he was, the huge word "Diet" on the box makes viewers laugh.

Big Box and Maru
Cat vs. cardboard storage box. Cat wins.

Posted on April 24, 2009 01:54

大きな箱とねこ。
Big box and Maru.

Maru can't take his eyes off the big box—he tries to stretch himself but still can't see inside. So he decides to climb onto the table, and . . . This is the famous video called "Ninja Neko" seen worldwide. Nobody expects a cat to do this kind of thing, but our star cat makes no bones about it. He simply can't let his fans down.

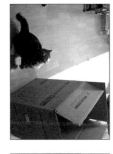

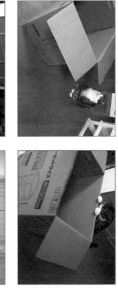

Get Cozy in a Wash Basin
He loves the feeling of being hugged.

Posted on August 27, 2008 01:54

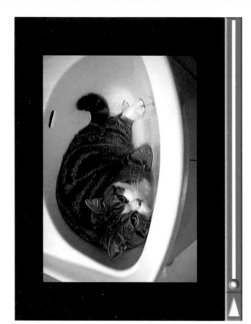

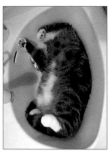

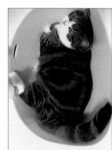

Though fairly static, this was ranked number four, probably due to the hit "Cat Hot Pot" video from the previous year. Maru has loved snuggling in basins ever since he was a little kitten. You can't get enough of his widely opened hind legs along with the exposed and vulnerable comfy pose.

Sliding Cat
Sliding into a box three times in a row.

Posted on August 2, 2008 00:30

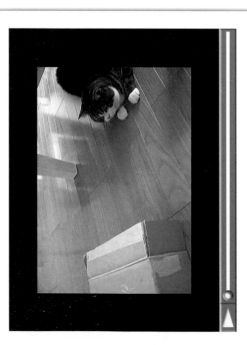

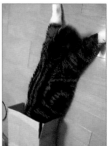

A memorable performance like the first video, only with even greater speed. Note the signature pose of straddled legs and rock-solid wagging tail, which is already well established by this stage.

I Am Maru.

Video introduction to Maru based on 2008 clips.

It's long.

Posted on January 11, 2009 05:15

まるです。
I am Maru.

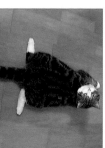

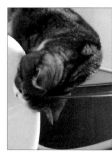

Maru's introductory video assembled from footage shot in 2008. Five minutes and fifteen seconds is a bit long, but you will be enchanted by its many features. A good primer on Maru.

Masked Cat #2

You can see his face peeking through the hole.

Posted on March 20, 2008 03:16

覆面ねこ 2。
Mask Maru.

Nobody knows why Maru puts his head inside a paper bag. First he feels frustrated, but soon he begins patrolling the house with the bag on his face. This is hysterical, but his real intent is a mystery.

Electric Heating Cat

Playing underneath a table covered by an electric blanket.

Posted on November 22, 2008 01:19

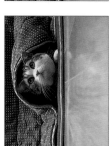

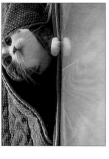

As if wanting to scare passersby, Maru pokes his head out from underneath the electric blanket and retreats. Each time he does this, Maru's face pulls into a funny face.

Sliding Cat 2

Final outcome of intensive training.

Posted on December 12, 2008 00:51

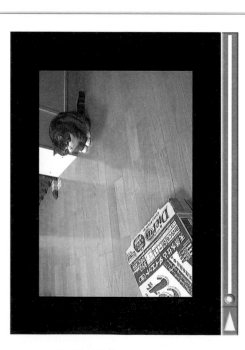

This was produced after the "Intensive Training" video taken two months before. Shot from multiple angles, this collection of ten speedy performances reveals that his training has really paid off. Maru's rocketlike final take must be seen to be believed!

Hiding Cat

Whenever he sees an empty container, he has to be inside.

Posted on February 6, 2009

入るねこ。
Maru enters.

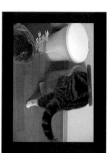

Maru handily opens the lid with his nose and stuffs his entire fat self into the garbage can. It fits perfectly like a tailor-made suit. The fact that he sits there quite still as if taking a hot bath makes this scene so surreal.

Wannabe Inside

Maru has to put his head inside any container.

Posted on September 7, 2008

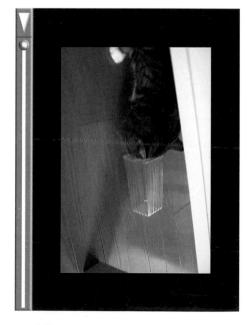

Whenever there is an empty container, Maru will put his head in at a y cost. What will he do when he finds such a small container? Sure enough, he puts his head completely inside. (This container has small holes.) I didn't know his face was this small!

Afterword by the Author

I always enjoy playing with Maru and keeping up my blog and videos about him, and I'm now very happy to have the opportunity to release this book. Thanks to Maru, I was able to meet a lot of people—those whom I just met, who regularly check on Maru and send lots of warm words, and who made a proposal to put out Maru's book. I feel deep gratitude to Maru, who's been the most precious and irreplaceable friend to me.

So here's to many more years of fun and play together, Maru! Love you!

あとがき

まると楽しく遊びながらブログや動画を続けてきて、今回このように本を出版させていただく機会に恵まれ、本当にうれしく思っています。はじめましての方も、いつもたくさんのコメントをくれるまるファンのみなさんも、そして「まるさんの本を出しませんか」という声をかけてくださった方々も、すべてはまるが繋いでくれた縁です。かけがえのない存在のまるさんに感謝しつつ、これからも楽しく遊びながら、仲良く同居していきたいと思います。

ということで、これからもよろしくね、まるさん!

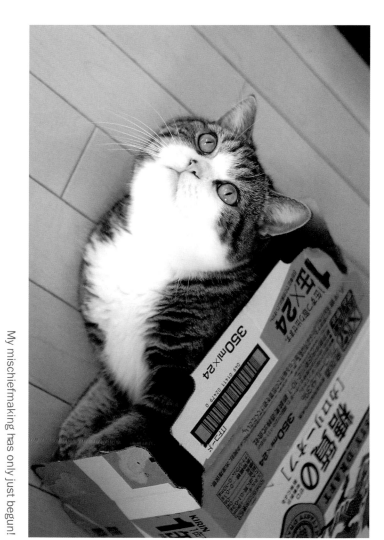

My mischiefmaking has only just begun!

まだまだやんちゃしますよ！

First published in Japan in 2009 by Tokimeki Publishing. English translation rights arranged with Tokimeki Publishing through Japan UNI Agency, Inc., Tokyo.

HarperCollins books may be purchased for educational, business, or sales promotional use. For information please write: Special Markets Department, HarperCollins Publishers, 10 East 53rd Street, New York, NY 10022.

FIRST U.S. EDITION

Library of Congress Cataloging-in-Publication Data has been applied for.

ISBN 978-0-06-208841-3

11 12 13 14 15 DIX/PH 10 9 8 7 6 5 4 3 2 1